CHRISTOPHER HART'S DRAW MANGA NOW!

Bishoujo Beauties

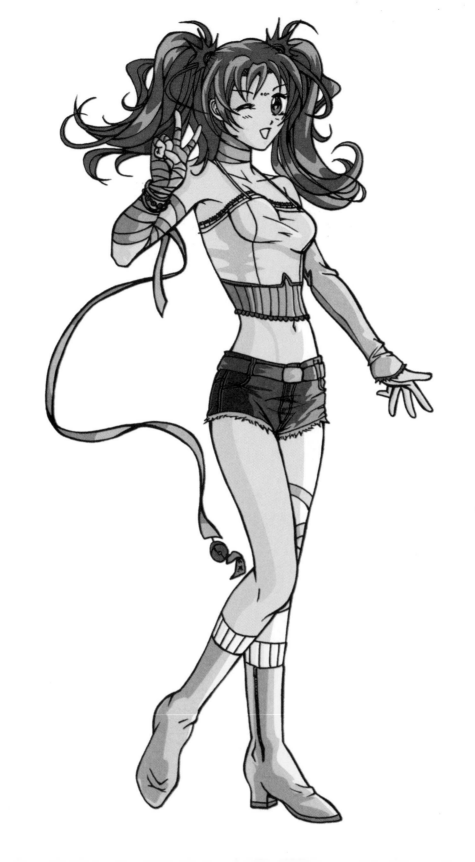

Bishoujo Beauties

Christopher Hart

Watson-Guptill Publications
New York

Published in the United States by Watson-Guptill Publications, an imprint of the Crown Publishing Group, a division of Random House LLC, a Penguin Random House Company, New York.

www.crownpublishing.com
www.watsonguptill.com

WATSON-GUPTILL and the WG and Horse designs are registered trademarks of Random House LLC.

This work is based on the following titles by Christopher Hart published by Watson-Guptill Publications, an imprint of the Crown Publishing Group, a division of Random House LLC.: *Manga Mania Bishoujo*, copyright © 2005 by Star Fire LLC; *Manga Mania Occult and Horror*, copyright © 2007 by Star Fire LLC; and *Manga for the Beginner Shoujo*, copyright ©2010 by Cartoon Craft LLC.

Library of Congress Cataloging-in-Publication Data

Hart, Christopher
 Christopher Hart's draw manga now!: bishoujo beauties/Christopher Hart.—
First edition.
 p. cm
1. Women in art. 2. Comic books, strips, etc.—Japan—Technique.
3. Cartooning—Technique. I. Title. II. Title: Bishoujo beauties.
 NC1764.8.W65H369 2013
 741.5'1—dc23 2013028865

ISBN 978-0-385-34603-0
eISBN 978-0-385-34604-7

Cover and book design by Ken Crossland
Printed in the United States of America

10 9 8 7 6 5 4 3 2 1
First Edition

Contents

Introduction

Bishoujo is a Japanese term that means *beautiful women*. Knowing how to draw these ultra-glamorous characters is an essential skill for every aspiring *mangaka* (*manga artist*). The bishoujo genre encompasses a wide range of character types and subgenres, from uniformed schoolgirls to the immensely popular Magical Girl subgenre, and from heroic fighter pilots of the Sci-Fi genre to fairies, martial arts masters, undercover agents, and much, much more.

As you flip through the pages, you'll see the widest possible assortment of bishoujo characters in a variety of styles. Drawing the beautiful eyes, the gentle contours of the face and figure, the hair, the lips, can all be tricky. We'll go through all of these individual elements that make up a bishoujo character. In no time, you'll be able to put them all together and create "bishies" of your own!

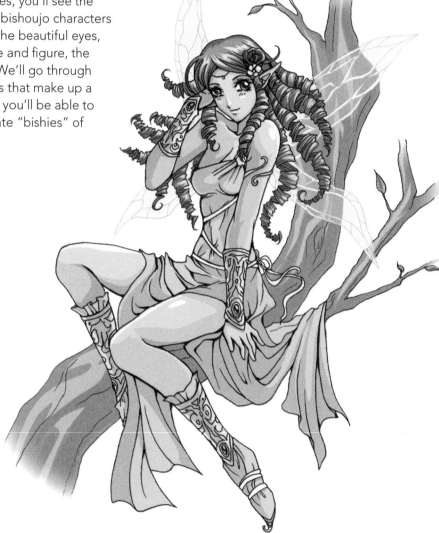

To the Reader

This book may look small, but it's jam-packed with information, artwork, and instruction to help you learn how to draw manga like a master!

Bishoujo characters are the alluring, attractive female characters in manga, and knowing how to draw them will bring your manga art to the next level. We'll start off by going over the basics you need in order to draw these characters. Pay close attention; the material we cover here is very important. You might want to practice drawing some of the things in this section, like important poses, expressions, and character types.

Next, it'll be time to pick up your pencil and get drawing! Follow along my step-by-step drawings on a separate piece of paper. When you draw the characters in this section, you'll be using everything you learned so far.

Finally, I'll put you to the test! The last section of this book features drawings that are missing some key features. It's your job to finish these drawings, giving characters the clothes, expressions, and friends they need.

This book is all about learning, practicing, and, most important, having fun. Don't be afraid to make mistakes, because let's face it: every artist does at some point. Also, the examples and step-by-steps in this book are meant to be guides. Feel free to elaborate and embellish them as you wish. Before you know it, you'll be a manga artist in your own right!

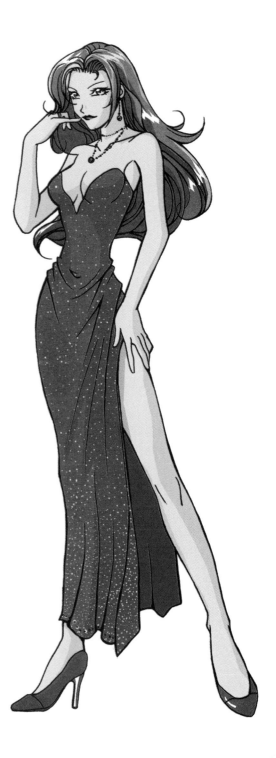

PART ONE
Let's Learn It

The Head

The outline of the head should be simple and subtle—no hard angles, except for the famous pointed manga chin. Allow the eyes and hair—not the shape of the head—to provide the glamour. And, don't rush; for the best results, approach this in a thoughtful way.

Front View

This is a typical manga girl who, depending on her costume, could be anywhere from sixteen to twenty years of age. Just as in the shoujo genre, the eyes take up a large part of the face.

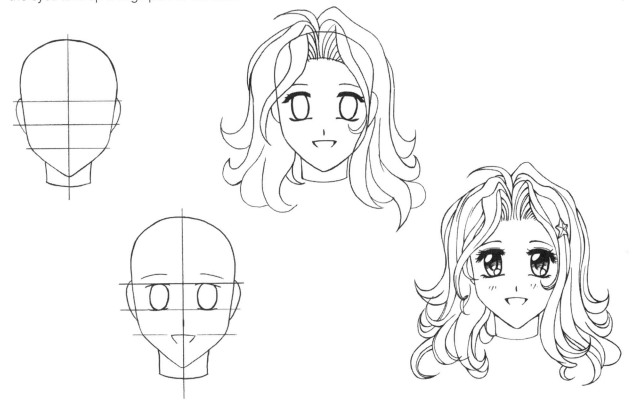

Side View

In order to maintain the character's femininity in the side view, it's essential to emphasize the curve of the forehead, and allow it to gently sweep into the bridge of the nose. There should be a considerable amount of head behind the ears. The underside of the jaw should always look soft, never bony, and it should rise up to the ear on a gentle curve.

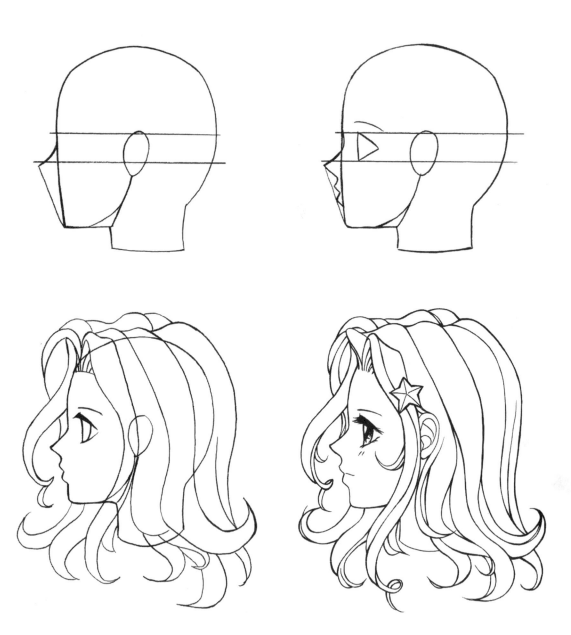

3/4 View

In this view, very little of the rear mass of the head (behind the ear) is visible. Because her face is slightly turned away from us, we see far more of the near side of the face than of the far side.

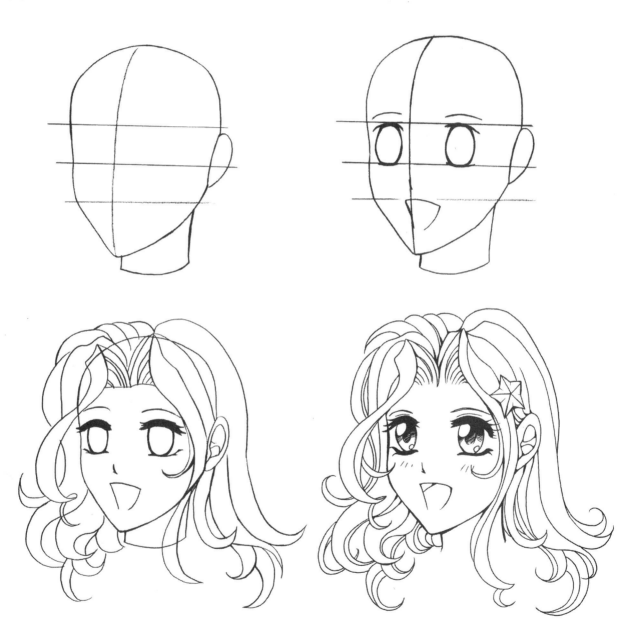

The Details of the Head

The attractive female manga head is made up of three elements: the basic structure and outline, the facial features (including those amazing manga eyes), and a dramatic hairstyle.

Captivating Eyes

Enchanting eyes are an essential part of the beautiful women of manga. Eyes are the focus of the face and are more important to the expression than any other feature. They make a stronger statement about the character than the costume does. Who has ever seen a seductive villainess without long, elegant eyelashes, or a pretty heroine without large, glistening eyes? The eyes create the character. In fact, you could almost say that the character is created around the eyes.

Most beginners use the same shape of eye for every female character they create. But eyes are not "one size fits all." Different character types require different eye shapes. A young girl will have a different eye shape than a twentysomething-year-old woman.

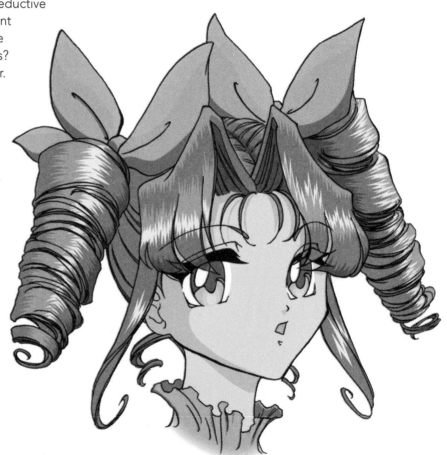

Classic

 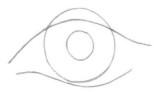

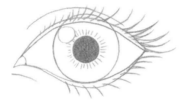 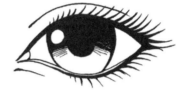

Oversized

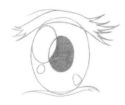 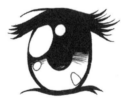

Slender

 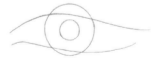

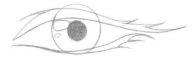 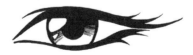

Side View

The side view of the eye is easy to draw. Partly, this is due to the fact that you don't have to line up two eyes evenly, as is required in the front view. The shape is basically triangular. The lashes feather in front and back.

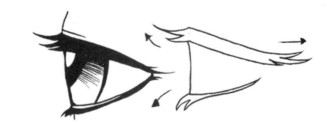

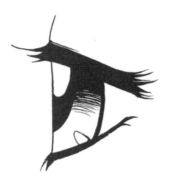

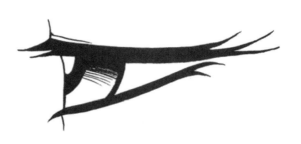

Simple vs. Detailed Eyes

Here are a few more popular eye types, divided into two categories. The top row represents the cleaner, simpler look, with bold, crisp lines and much fewer sketch marks. The bottom row features sketchier eyelids and lashes, as well as shading on the eyeball itself. The top look is used for younger characters, and the Fantasy and Sci-Fi genres. The bottom row is more for romantic and alluring characters.

Younger Eyes

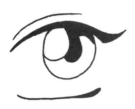

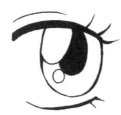

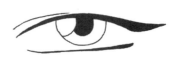

Mature Eyes

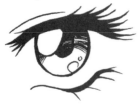

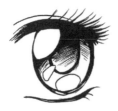

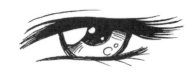

The Mouth

Do you draw full lips or a single line? Do you use continuous or broken lines? Only female characters have full lips. And thicker lips are, generally, for more mature characters. Also, the more attractive the character, the thicker the lips should be.

Leaving some lines broken is a cool look, because the eye naturally tends to fill in the gaps in the lines. With the broken-line style, you can place an accent mark just above the central dip in the middle of the upper lip and a small shadow below the bottom lip.

When the mouth is open, the upper teeth tend to show; the bottom ones do not, unless the character is angry. The upper teeth are not indicated with a straight line across the mouth but with an upward-curving one.

Full

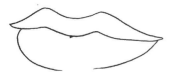 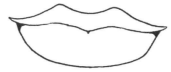 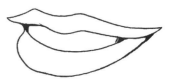

Broken Lines—with Top Lip Indicated

Broken Lines—without Top Lip Indicated

Creating Expressions with the Mouth

Beautiful manga characters have a subdued look that makes them alluring. But when they react, they do so with big emotions. A great way to convey this is to use the mouth as a vehicle for emotions—it's simple! There are no wallflowers in manga! A character won't lose her femininity when she has a big outburst of emotion, so long as she returns to her softer side once the moment of agitation subsides.

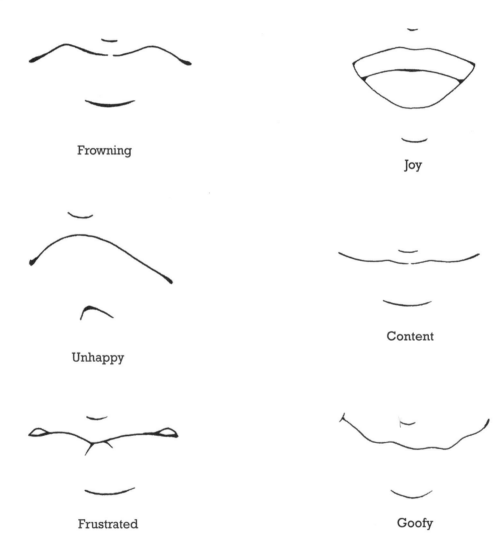

Frowning

Joy

Unhappy

Content

Frustrated

Goofy

Anger

Shock

Rage

Protest

Ridiculing

Devilish

Bishoujo Hair

Bishoujo characters all have big hair. It's a
hugely important element in every character's
design—in fact, it will, when properly drawn, add
glamour and brilliance to your characters. It can
be graceful or cutting edge. Either way, use it to
make a statement.

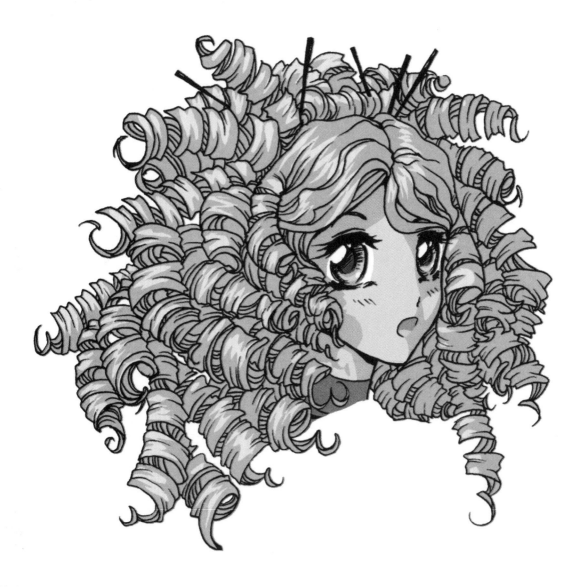

Short and Trendy Hair

Short hair can be very attractive and
very sharp looking. It's a great match
for hip, cosmopolitan characters.
Their clothes will also have to match
their sleek hairstyles; in other
words, no flowing robes or fantasy
gowns for short-haired bishoujo
characters. They get short skirts,
tight jeans, or Sci-Fi body-
hugging space suits.

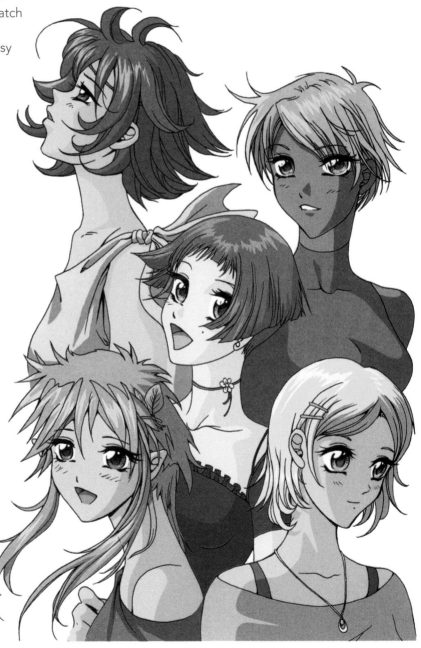

Long Hair

On real people, long hair means shoulder length, more or less. On bishoujo characters, however, it can mean as long as the entire figure! Remember, the longer the hair, the more swirls you should add to it to keep it looking graceful and glamorous.

The Wild Side of Hair

You can go as far out as you like with the hair, provided that it's consistent with your vision for the character and her costume. Aren't these cool?

Keep in mind that the hairstyle reflects the personality of the character. For example, a wicked queen will have an extreme and sharp hairdo, while a pretty tomboy will have a scruffy hairstyle.

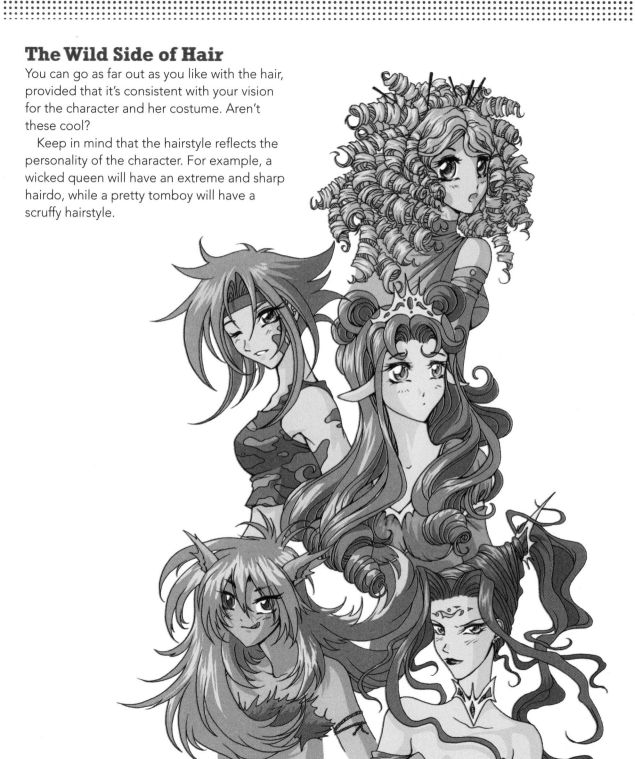

Body Types

Bishoujo characters (fully mature young women) are mostly found in the Fantasy, Sci-Fi, Action, and Occult genres. To give you an idea of a bishoujo character's size, let's compare them to characters of other genres. The *shoujo* type is a young teen who retains the cute, perky, and pretty look of adolescence. The *kodomo* characters are younger still, with no real muscle tone or distinct female body shape. They star in adventure-type comedies. And *chibis* are the famous minipeople of manga who are small, chunky, and adorable. They can show up in any genre for comic relief.

Kodomo

Chibi

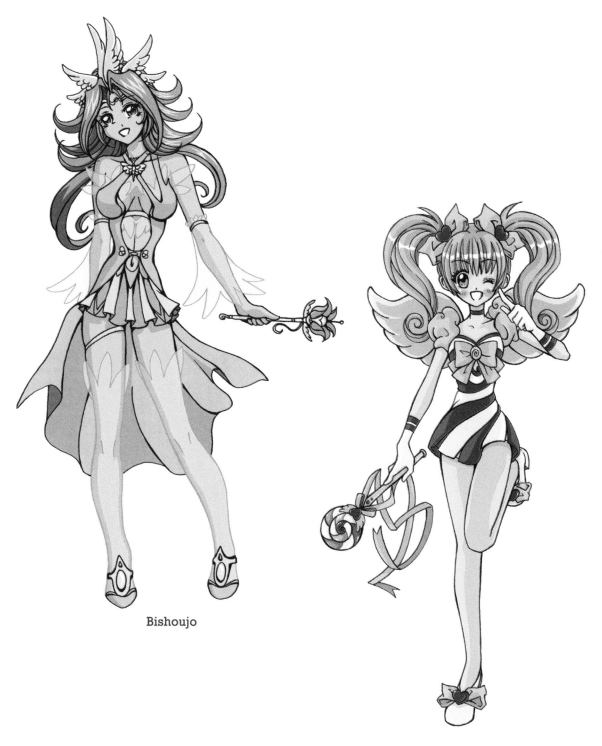

Bishoujo

Shoujo

The Bishoujo Body

In addition to facial expressions, the figure is an important tool for communicating feelings to the reader; using it will make your manga more successful. The common problems beginners have are getting the proportions and shapes of the major body parts correct. The legs and neck end up way too long, for example, or the hips and chest are much too skinny. But by starting with a basic construction of the female figure, you can easily avoid these problems. Once you get this down, you can move on to the more advanced poses and costumes that help your characters convey the emotion of the story.

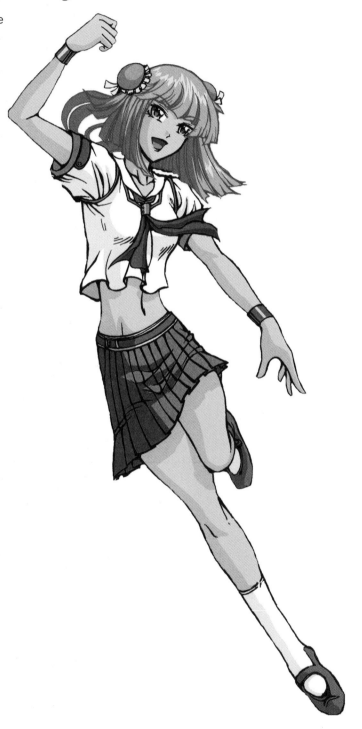

Front View

Arms Down

In the construction drawing, the chest and hip areas are sketched as ovals, with the chest being the larger of the two. Drawing these ovals first, and the frame of the body around them second, establishes the correct proportions at the outset. The horizontal line at the top of the chest (the collarbone) creates a strong visual plane. It's often drawn at an angle, which makes the pose more dramatic. The line of the hips tilts in the opposite direction than the collarbone.

When down, the relaxed arm will hang at mid-thigh level. The legs are approximately 25 percent longer than the arms.

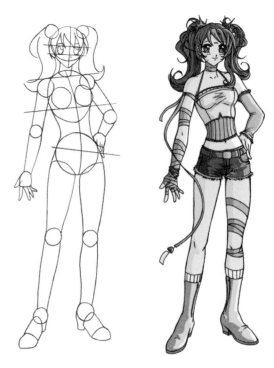

Arms Up

When the arms are raised above the head, the collarbones bend at the pit of the neck, forming a wide V.

To make sure the weight is distributed correctly, you need to find the center of balance. To do this, draw a straight line from the pit of the neck to the ground. In this case, *her* right heel is the center of balance. And since more of her body mass appears to the left of the center line, she must lean slightly back to the right to maintain balance.

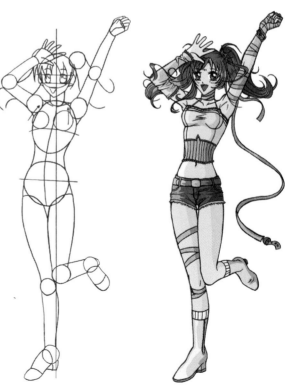

Side View

In the side view, the chest tilts up slightly while the hips tilt down slightly, as indicated by the horizontal guidelines. These two forces combine to create an attractive curve in the small of her back. Also observe the shoulder socket: it should fall within the oval of the chest area. And here's one more item to keep in mind: even though it's only slightly noticeable, the far foot must be placed a tiny bit higher than the near foot, due to the effects of perspective (when things that are farther away from us appear smaller than things that are closer to us).

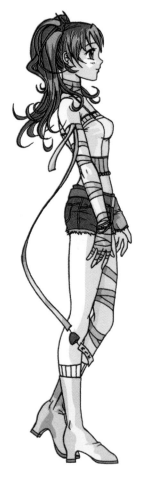

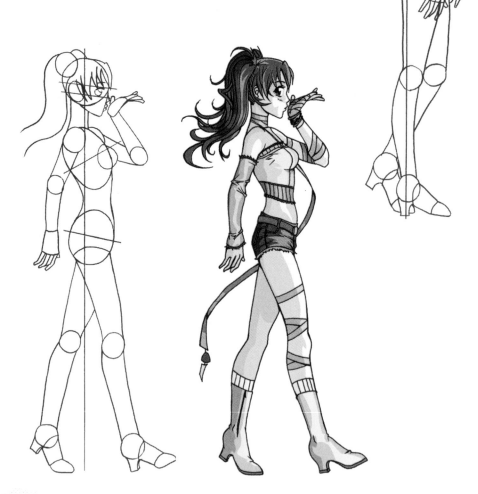

3/4 View

When you turn the body in a 3/4 view (halfway between a front and a side view), the center line becomes all-important. Serving the same function as it does when you draw the head, the center line runs vertically through the center of the body. It's not used to indicate balance but is a guideline to divide the body equally in half. When the body is turned 3/4 of the way around, the center line will appear to be 3/4 of the way over. In addition to aiding the artist in visualizing the body correctly, the center line helps the artist draw the costume in the correct proportions. Belt buckles, zippers, and buttons often appear down the middle of the body, so they naturally fall on the center line.

In addition, artists use circles—spheres, really (because they're envisioned as three-dimensional)—to represent the various joints of the body. This serves as a reminder that the joints have mass. Many beginners draw joints that are far too thin, so this is a good technique to use.

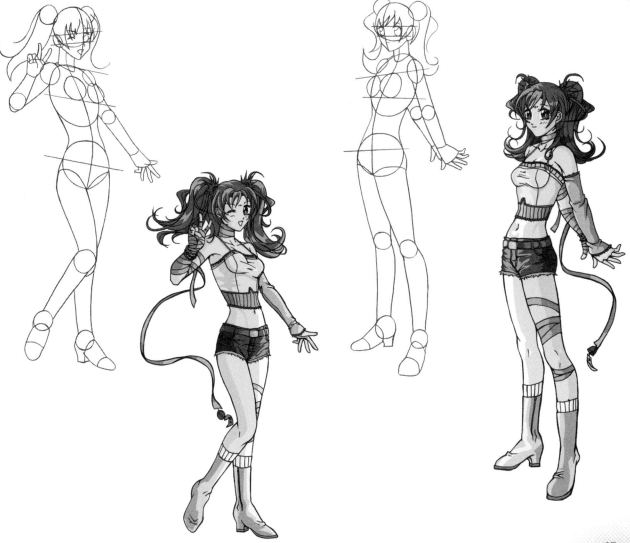

Poses

What makes a pose alluring? First of all, an attractive pose is fluid, never stiff. Generally, the legs are placed apart or one leg bends more than the other. This causes the hips to tilt to one side, which is essential for a dynamic, flirtatious pose. Don't position the hips square; they must be tilted unevenly if they are to be attractive. You can also push the hip area forward, which causes the figure to lean back and the breasts to rise up slightly.

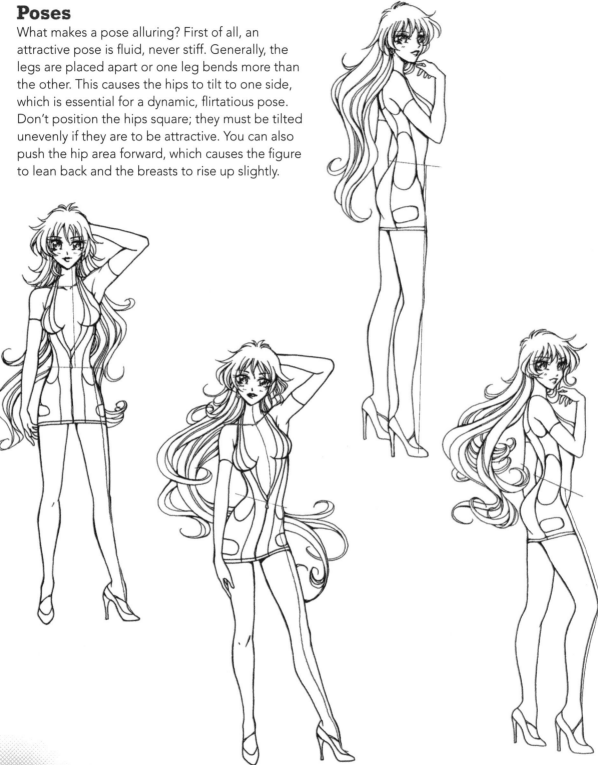

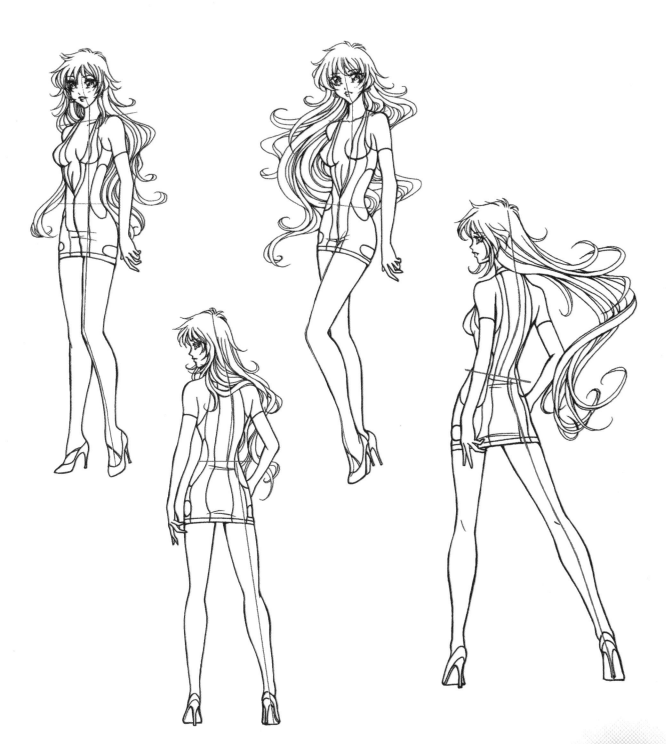

Advanced Body Language

There are many ways to portray an emotion through body language. But ultimately, the most important tool you have is your own gut instinct. After you rough out a drawing, pause a moment to see whether it conveys the emotion you're trying to portray. If it doesn't, then you've still got work to do. But if you can look at your drawing and say, "Yeah, she looks tired [or happy or in love or whatever emotion you're after]," then you've nailed it and you can proceed. It's your job to be the final arbiter of what works and what doesn't. This section contains a few more advanced poses that you can copy exactly as they are for practice or that you can use as a springboard when developing your own original characters.

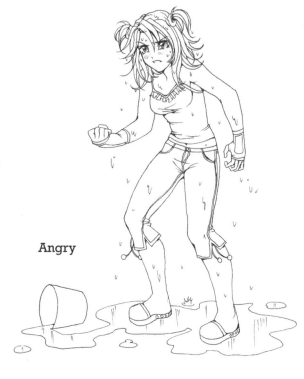

Angry

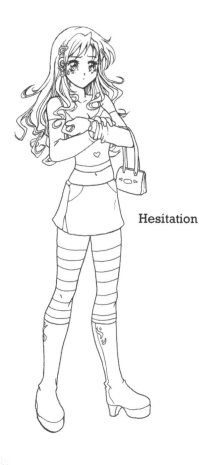

Hesitation

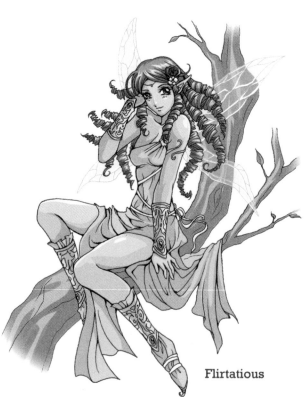

Flirtatious

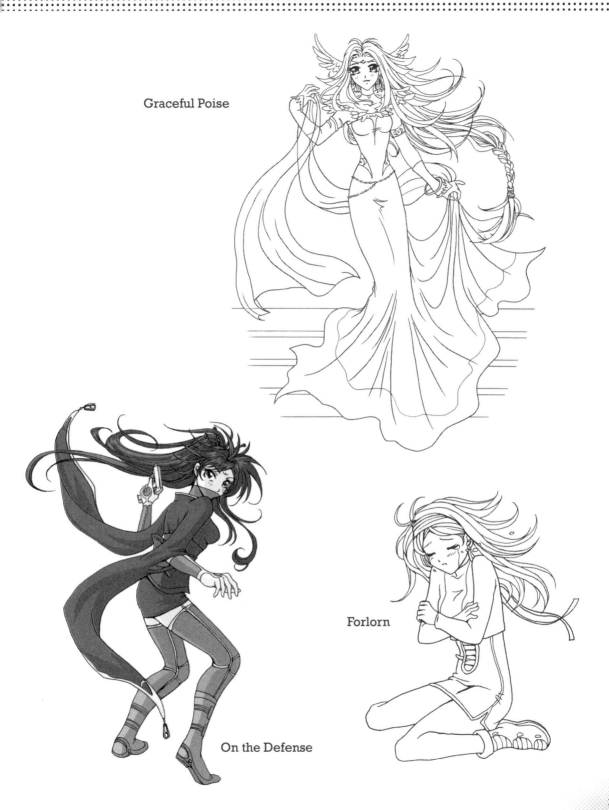

Graceful Poise

On the Defense

Forlorn

Drawing Costumes

Futuristic uniforms and fantasy costumes are widely seen on bishoujo characters; this is a great way to put your own personal spin on a character, and give them an exciting identity, whether it's an ultra-sleek cyborg, an intergalactic glam-girl, a stealthy secret agent, or a twirling fairy princess! Here are some examples to get your imagination started. When drawing characters in costume, it's always a good idea to sketch out the underlying figures before adding the clothes or costume. Pros adhere to this rule of thumb.

Space Commander

She's a space pilot, perhaps even an on-board scientist. She wears an insignia on her chest and helmet that tells us she's part of the official space fleet. She would be more at home in a Sci-Fi manga than a Fantasy manga.

Winged Fighter

Sometimes, it's not the clothing that identifies the character, but other elements, such as wings, fins, or scales. When using wings, make them oversized and feathered for good characters.

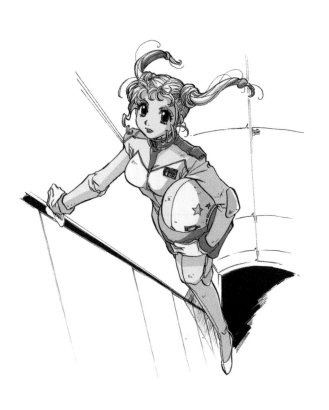

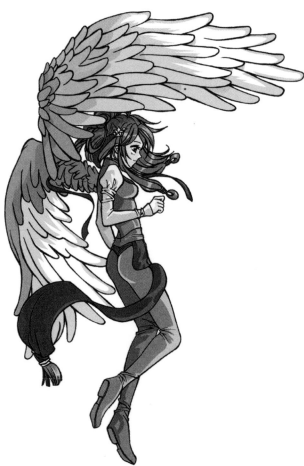

Sci-Fi Girl

In manga, capes are more of a design element than a tool to show flying, as they are in American-style comics. It may be physically impossible, but having ponytails that are located above the helmet is a cool look.

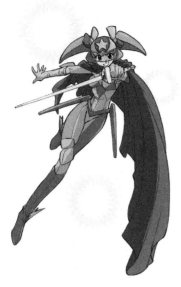

Elfin Girl

The Fantasy princess is a favorite character in bishoujo. The elfin ears on this character identify her as a magical type. Note that, in manga, faerie or elfin ears can point down as well as up.

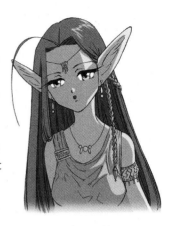

Twirling Princess

She wears a dramatically flowing or billowing dress that reveals the ruffles of the undergarments. A princess never wears boots, but has dainty shoes instead. Note the amazing hair, ribbons, and petite crown that's almost a tiara.

Forest Fairy

This is an earthy elf who goes barefoot. Her garment is sleeveless. She wears jewelry on her upper arms and forehead (which is also an earthy sign), but no crown. The bird shows that she communes with nature's beings as a friend and equal, a gentle soul.

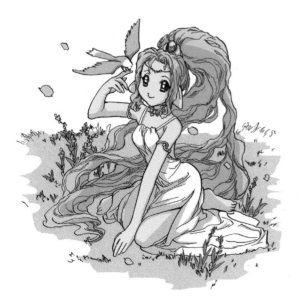

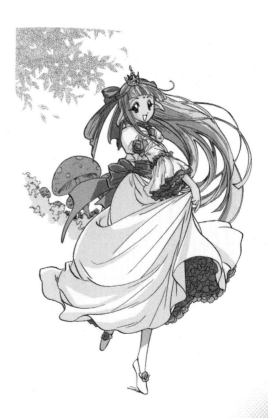

Bishoujo Style

Not all bishoujo characters are supersonic fighters; you might see some of these outfits on them, too! While some bishies wear racy, over-the-top outfits, you'll see other looks that are younger and more subdued, like a school uniform or a sweet, ruffly dress.

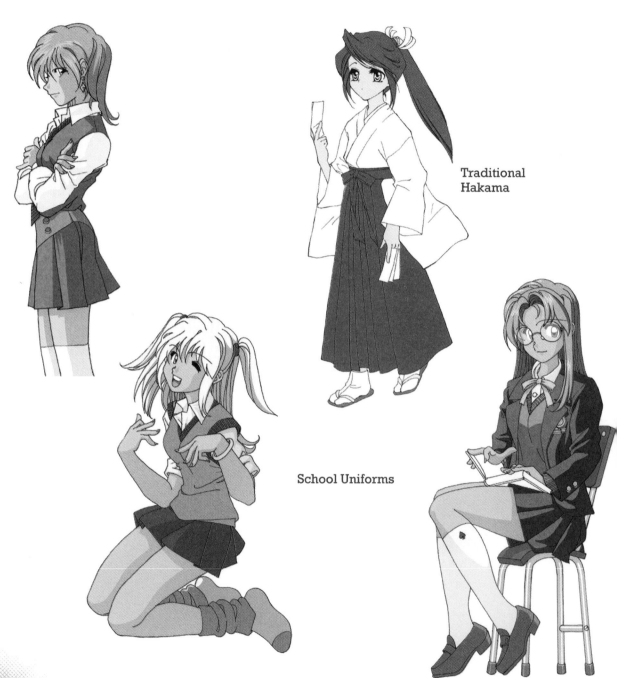

Traditional Hakama

School Uniforms

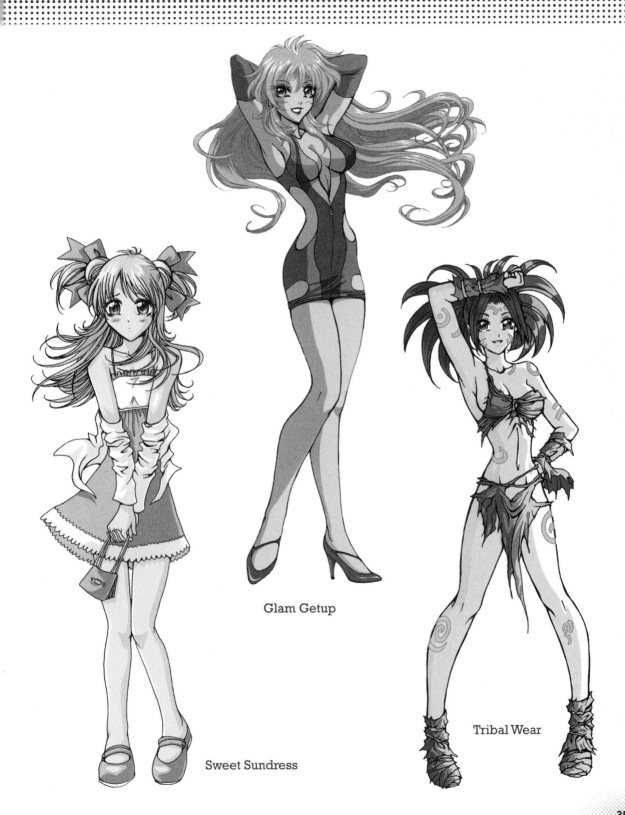

Glam Getup

Sweet Sundress

Tribal Wear

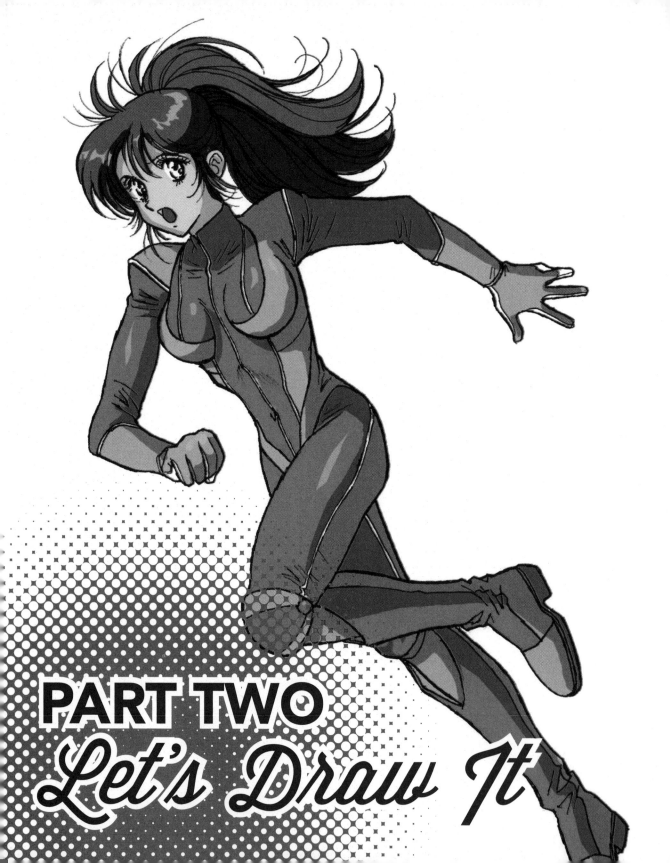

PART TWO
Let's Draw It

Stylish Figure

Let's put some costumes together with poses so that the personalities of the characters come through. This is a playful pose that works well with this attractive character who wears stylish, casual clothing. To create a playful look, keep the figure light on her feet, with a bounce to her walk.

Broken down into its elements, this lively pose is actually quite easy to draw. It might not seem that way if you only look at the finished drawing, but if you examine the first construction step, you can see how the pose breaks down. That's what you should be fixing your mind on. Most of the important decisions are made in the first construction step. With that locked in, you're actually more than halfway done, and everything else falls into place.

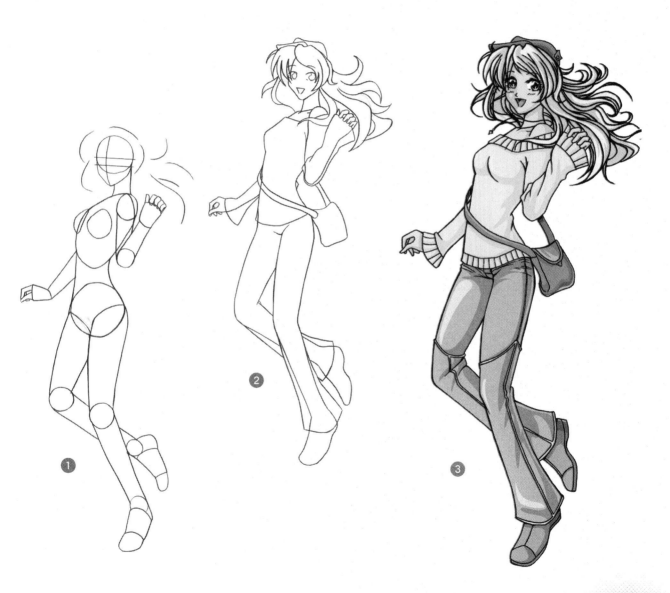

Sophisticated Woman

To get a figure that conveys that sultry look, draw long arms and legs. Give her an elongated waist area, and draw her shifting her weight to one leg. Heels, earrings, and a necklace complete the look.

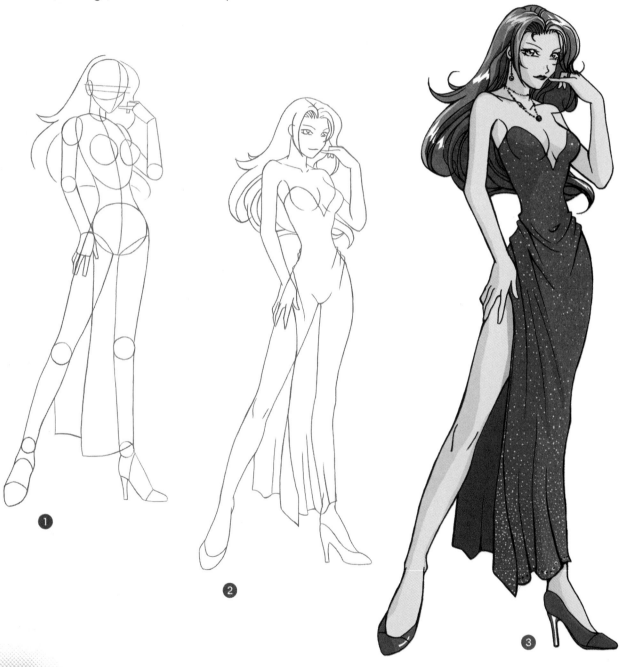

Warrior

In keeping with her character, this figure is more athletic and rugged than the previous examples. She's an expert with the longbow. A wide stance is used to add stability. Archers are an important part of the Fantasy genre.

Even though she has a warrior's heart, she should still have attractive features, such as dark eyelashes, a petite mouth and nose, and dramatic hair.

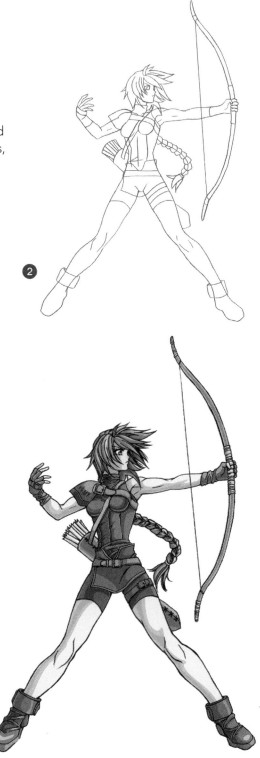

Classic Action Pose

This crouching posture is famously employed by spy characters working undercover. As she infiltrates enemy territory, she must take care not to reveal her presence. Therefore, her body language tells us she's hiding and crouching down. Keep the shoulders tensed and the character's back slightly hunched in a pose like this. The arm that holds her weapon should either be held straight or should be bent and at eye level—both ways show the character on edge, ready for a split-second response.

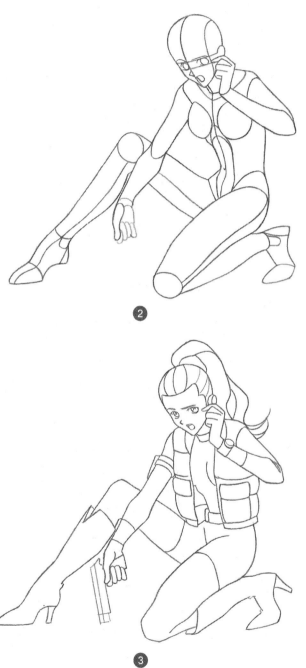

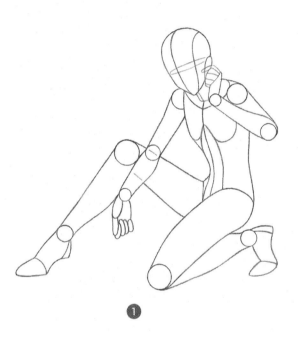

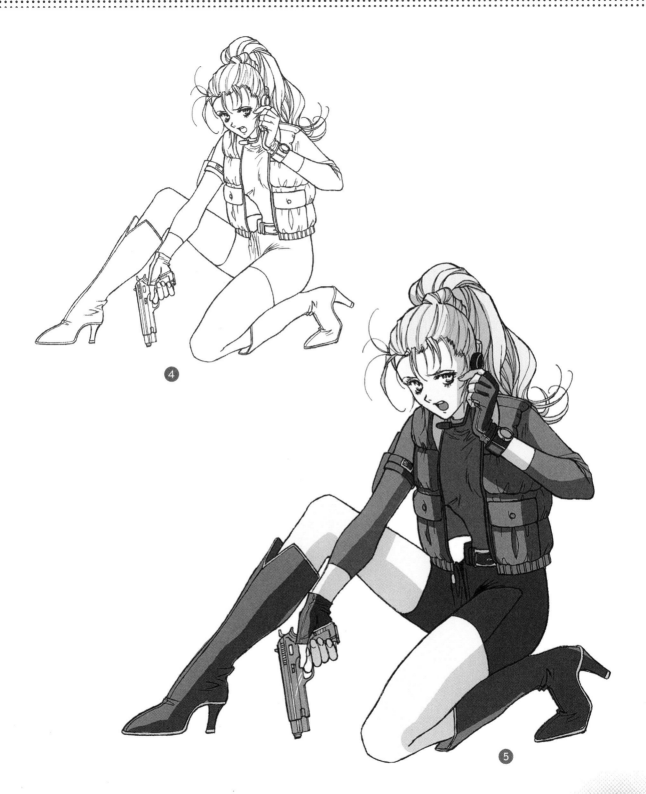

Running

Here's a good running pose. It's not the typical pose most artists think of. Instead of the legs being spread apart in the widest possible stride, they are depicted in a "crossover" position in midstride. While the open stride is very effective at showing a running character striving for speed, it also tends to make the character look frozen in time because it's so evenly balanced and symmetrical. The crossover position, on the other hand, looks like a quick snapshot—a moment captured in an action sequence.

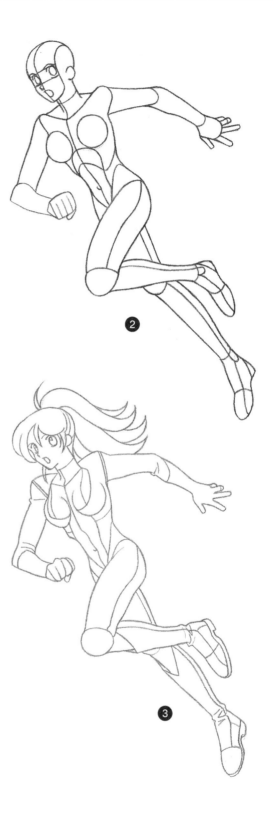

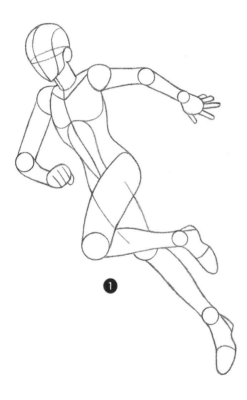

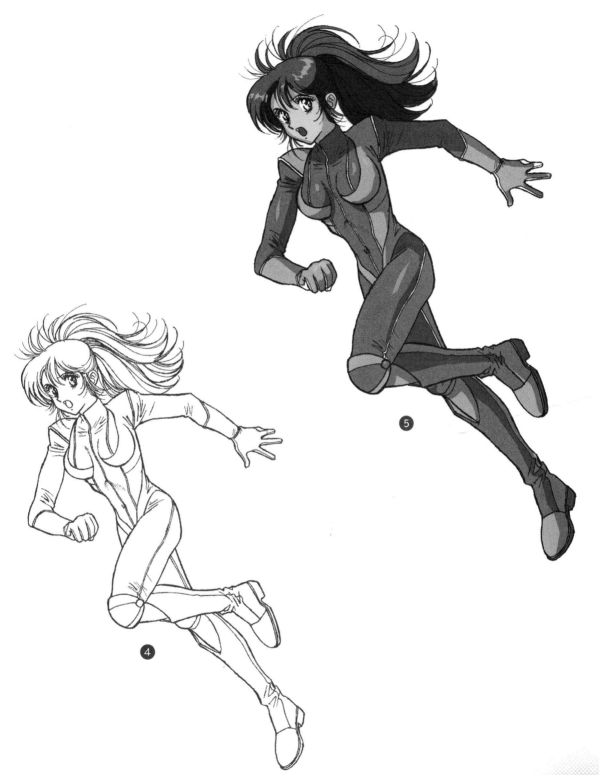

Martial Arts

In comics, martial arts should always look dramatic. Actual martial arts combat is more straightforward and far less flashy. But this is manga, and over-the-top action looks cool. More motion is always better than less. The stances should be open, with arms and limbs away from the body in mysterious positions. Vary the hand gestures between fists, flexed wrists, and claws.

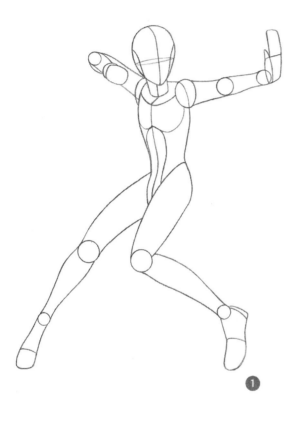

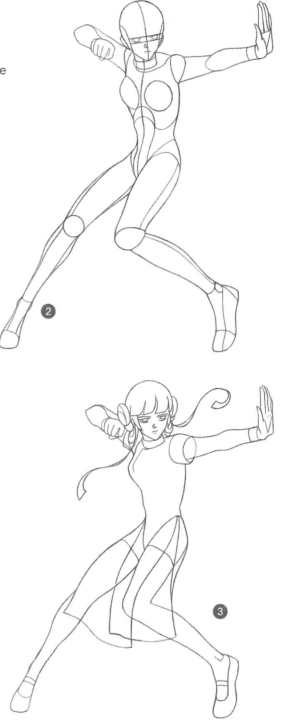

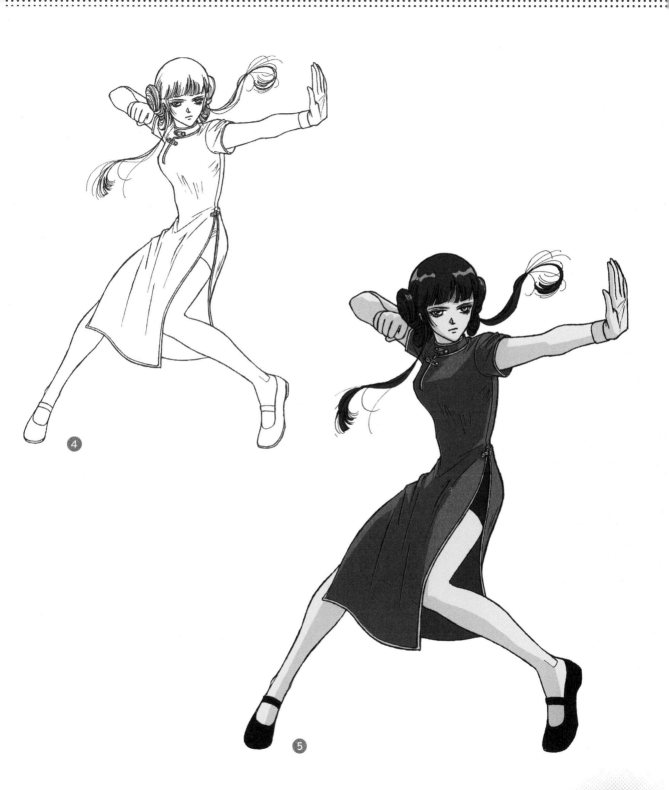

Villainess

Tall boots are a giveaway that she's in the Fantasy or Sci-Fi genre. But it's really the extreme hair and outfit that put her in the bishoujo realm. The cutouts on the waist area of the outfit are a cool look. But it's the eyes—with their heavy-duty mascara treatment and slanting eyebrows—that really exude evil thoughts.

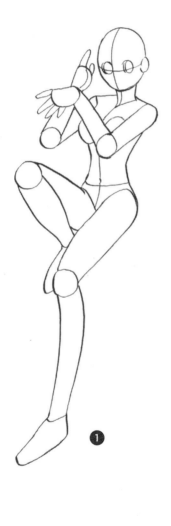

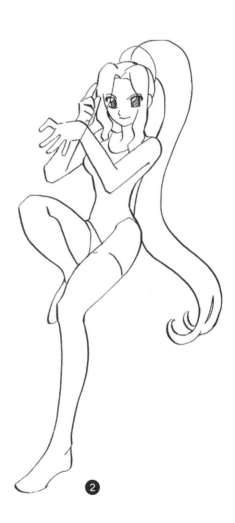

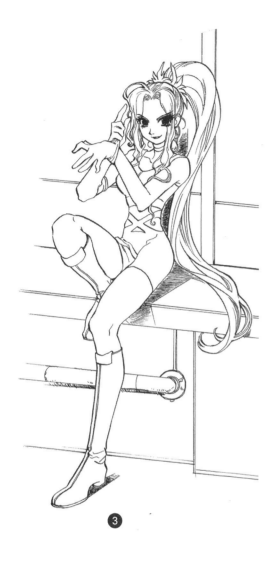

③

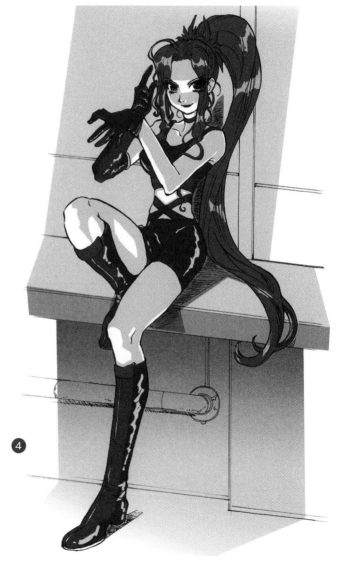

④

Beast Fighter

You won't find any flowers or scrunchies in her hair. She may be an older teen out to avenge the human race—but she packs a mean side kick! It takes a lot of power to fight beasts of darkness. So, she leaps with a *flying* side kick, instead of executing the kick from a standing position. To make her appear more mature, de-emphasize the overall size of her head, giving it more realistic proportions than the previous shoujo characters. Also, elongate her torso, giving her a sleeker midsection.

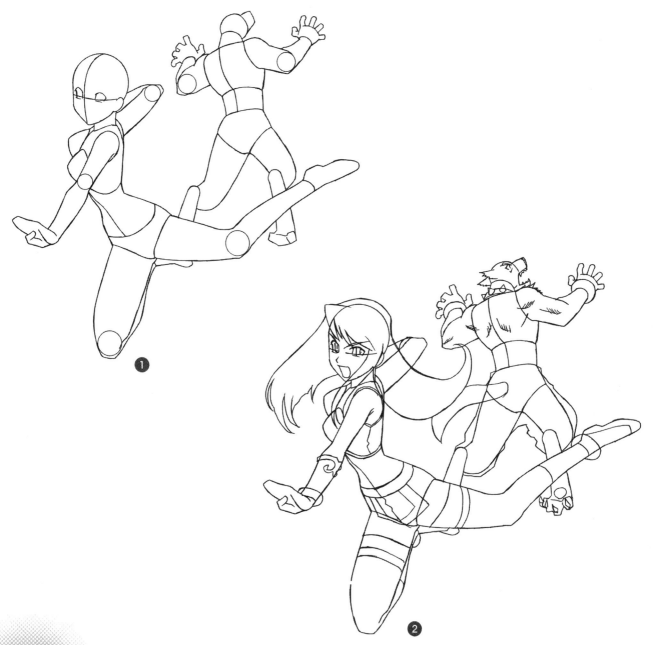

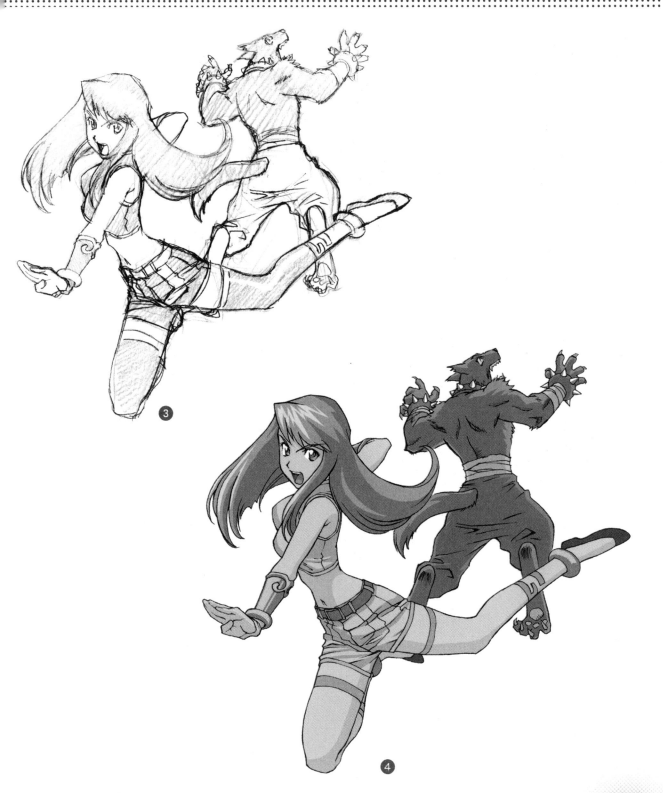

Dancer

Magicians and cabaret stars are a popular component of bishoujo. The lifted leg creates a common pose that reads "showgirl." Since she's a performer, she needs to twist her body to face the audience in front of her, even if she's walking sideways across the stage, as she is here.

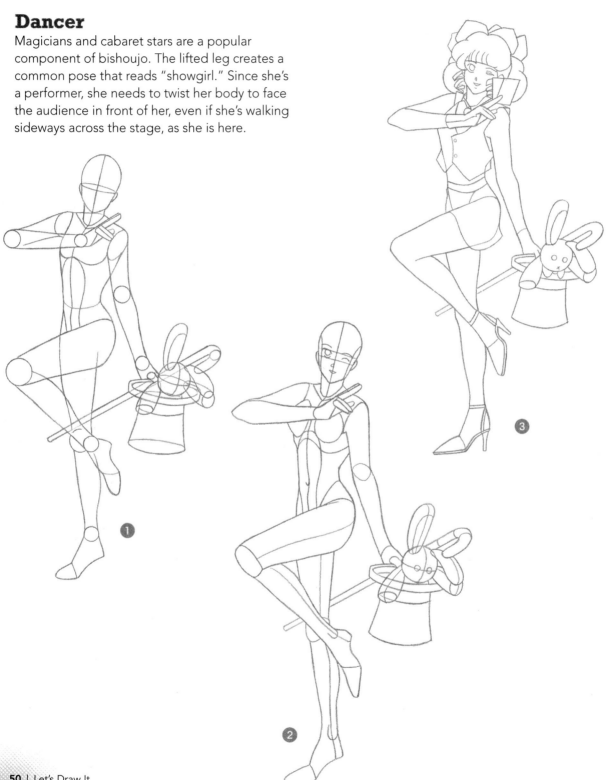

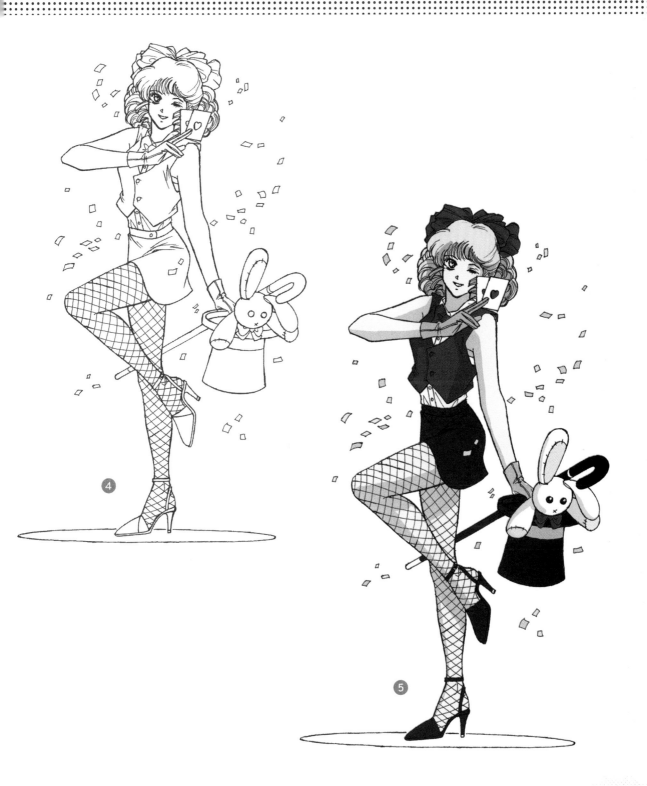

Scientist

Proper, seated characters sit with their backs
arched and their feet tucked back under their
chairs. The upper part of the outfit remains
unaffected by the seated posture, but the bottom
half bunches up and gets wrinkled.

This lab technician looks pretty but is unaware of
it. She has a long lab coat and wears her hair back,
with just a few pieces hanging loose.

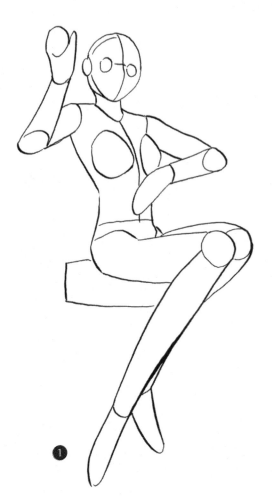

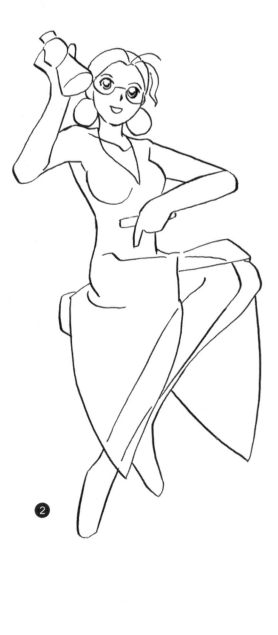

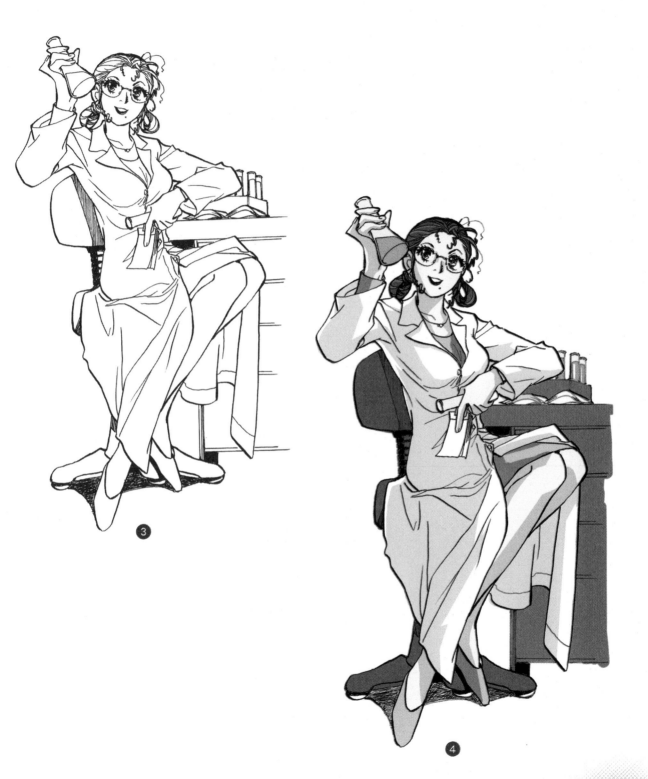

③

④

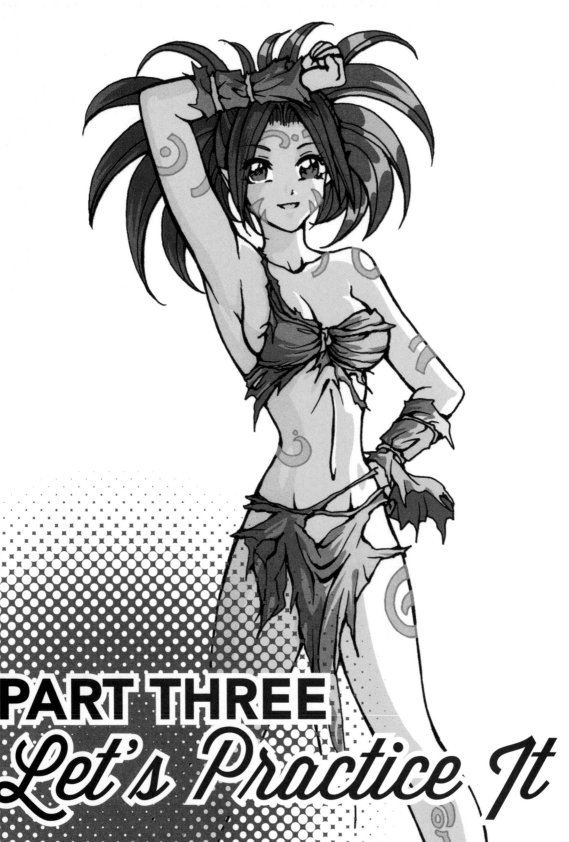

PART THREE
Let's Practice It

Add eyes to this bishoujo beauty.

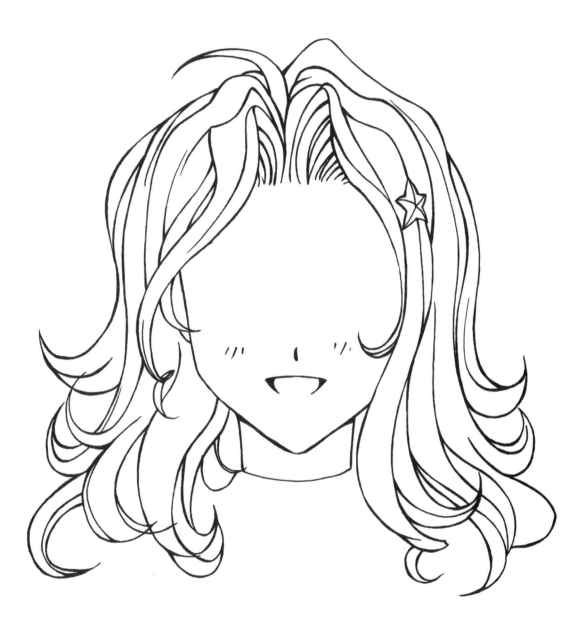

Take these ordinary hairstyles and turn them into glamorous, wild hairstyles.

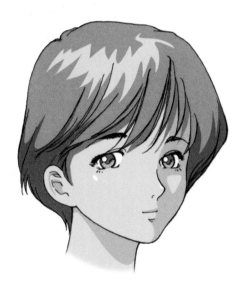

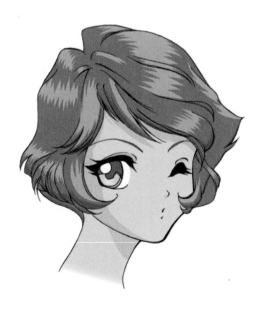

Add accessories to this hand. Then try drawing a hand, complete with rings, gloves, or bracelets, on your own.

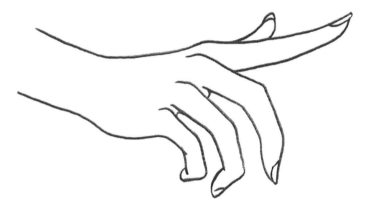

Draw the rest of these bishoujo characters' faces, based on these mouths.

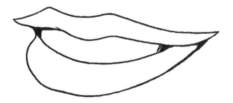

Draw in expressions on these faces.

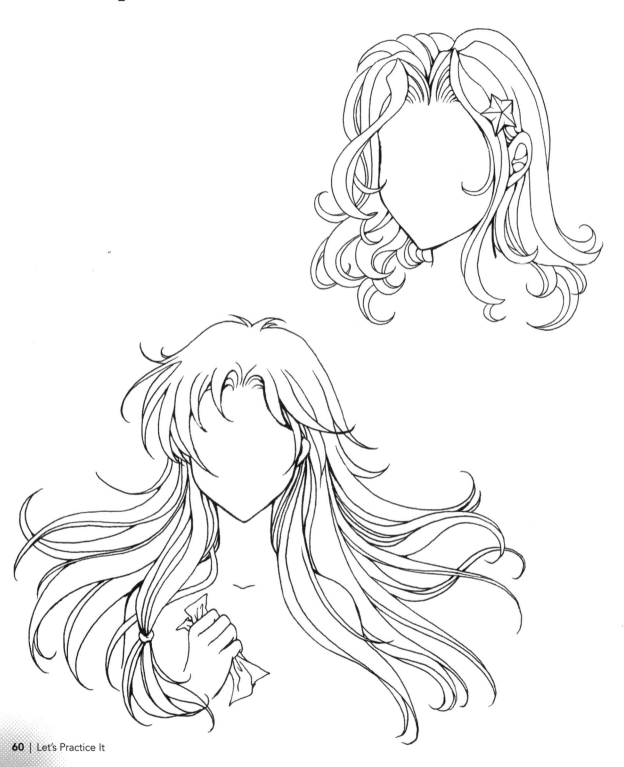

Add on this character's body.

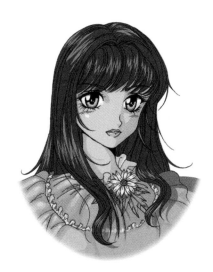

Transform this character's pose into one that's more dynamic.

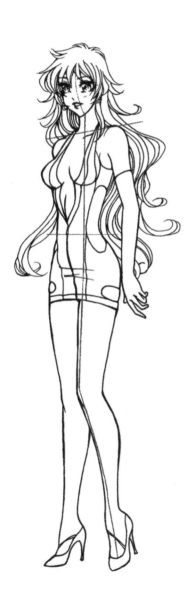

Finish drawing this bishoujo character, and give her a wild, over-the-top costume.

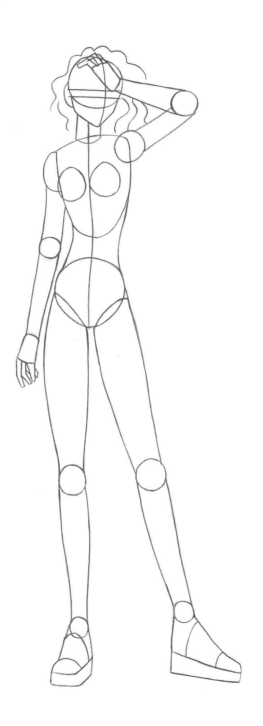

Also available in *Christopher Hart's Draw Manga Now!* series